Possibilities

that are YOU!

Volume 1: Transcendent Beauty

by

Alex Bennet

An imprint of **MQIPress** (2018)

Frost, West Virginia

ISBN 978-1-949829-00-6

MQIPress

Frost, West Virginia
303 Mountain Quest Lane, Marlinton, WV 24954
United States of America
Telephone: 304-799-7267
eMail: alex@mountainquestinstitute.com
www.mountainquestinstitute.com
www.mountainquestinn.com
www.MQIPress.com
www.Myst-Art.com

ISBN 978-1-949829-00-6
Opening verse by poet Cindy Lee Scott
Front cover collage by Cindy Taylor
Back cover by Corbie Crouse, Reefka Schneider, and Jackie Urbanovic
Graphics by Fleur Flohil

Oh, beautiful soul, love transcending
Feel freedom's truth ascending
Thoughts, feelings, actions take hold
Beaming beauty from within, behold.

-Cindy Lee Scott

Preface

This book is for YOU. Regardless of economic success or educational prowess, beyond cultural influences and habitual routines, YOU have been and continue to be a student of life. And since our time in this learning sphere is precious, the challenges and opportunities are both rapid and continuous, always offering new insights. YOU are a verb, not a noun. Forget what you were taught in grammar school!

Now, we live in a world of demanding challenges, where people and systems are rebounding from control, rebelling from eras of real and perceived suppression of thought. With the acceleration of mental development over the past century has come increased awareness of human capacity, with economic success in small bites for many and large bites for the few, and for some coming with an arrogance that says, "Look at me. I'm right, you're wrong, and I'm not listening."

Because of our Economy's focus on the material, economic success begets economic success and the separation of wealth grows larger, flaming the difficulties of surviving in a CUCA world, that is, a world of accelerating change, rising uncertainty, increasing complexity, and the anxiety that comes with these phenomena.

Yet all of this **offers us, as a humanity the opportunity to make a giant leap forward.** By opening ourselves to ourselves, we are able to fully explore who we are. With that exploration comes glimmers of hope as we contemplate the power of each and every mind developed by the lived human experience!

As YOU move through your life of thoughts, feelings and actions—even when you have to repeat things over and over again as part of the experience—YOU are advancing toward the next level of consciousness.

Here's the bottom line. Everything that has been learned and continues to be learned is out there … and as a student of life, YOU have access to it all. So often it is expressed in ways that don't make sense because of the language and media being used. It just isn't presented conversationally, and you don't have a chance to ask questions from your unique point of view.

So, these little books—which we refer to as Conscious Look Books—are specifically focused on sharing key concepts from *The Profundity and Bifurcation of Change* series and **looking at what those concepts mean to YOU**.

These books are conversational in nature, and further conversations are welcome. We invite your thoughts and questions, not guaranteeing answers because there is still so much to learn, but happy to join in the conversation. Visit Mountain Quest Inn

and Retreat Center www.mountainquestinn.com located in the Allegheny Mountains of West Virginia or email alex@mountainquestinstitute.com

As my partner David reminds us: *Run with the future!*

Our gratitude to all those who take this journey with us, and a special thanks to the colleagues, partners, friends, family and visitors who touch our hearts and Mountain Quest in so many ways.

With Love and Light, Alex and David

Contents

Introduction

Do you remember the last time you watched a sunset, listened to music, or saw someone special and thought, "Beautiful!" How did you feel? Close your eyes for a moment and remember that feeling. There's a pleasurable tingle … maybe it's a warm wave swelling in your chest … a floating sensation of joy … a deep breath that exits with a smile. Whatever the feeling, it's a really *good* feeling, and it leaves you, well, *in a state of peace.*

So, what exactly is beauty? That's not an easy question to answer, because beauty means different things to different people. It is definitely based on the personal experiences of the individual. Of course, there are ways to talk about what beauty is. For example, in the 2007 movie *Next*, the hero, Nicholas Gage, says: "There's an Italian painter named Carlotti, and he defined beauty. He said it was the summation of the parts working together in such a way that nothing needed to be added, taken away or altered."

While to my knowledge there has never been an Italian painter named Carlotti, those words seem to make sense. Beauty is that special state where something seems, well, *perfect*, at least from a personal point of view! If it's a sunset we are

watching, there's just the right variety and amount of color. If it's the music we are listening to, the melody, tonal patterns and rhythm make my heart sing, or my head whirl. If it's that special someone walking through my life … just use your imagination for that description!

The psychologist Rollo May felt that a person who could apprehend beauty was able to discover truth. I tend to believe he may be right. The recognition of beauty begins with the freedom—and desire—to choose that which is beautiful. *Life is what it chooses to be.* When we choose beauty as our expression in life, or sense beauty around us, we are simultaneously exercising our individual choice and connecting to larger concepts of truth.

<<<<<<<◇>>>>>>>

INSIGHT: **Life is what it chooses to be.**

<<<<<<<◇>>>>>>>

Howard Gardner, a Harvard psychologist who developed the theory of multiple intelligences, a really bright mind, wrote a more recent 2011 book titled *Truth, Beauty, and Goodness Reframed: Educating for the Virtues in the Age of Truthiness and Twitter*. That's a pretty good title for today's world, sort of brings the old Greek philosophers' virtues of truth, beauty and goodness into our context.

Gardner agrees that beauty is the property of experiences, because any experience can be considered by the individual experiencing it as beautiful. Consider your personal experiences of beauty. Gardner identifies three things that are required to have these experiences. They are (1) it has to be interesting to the individual, (2) there has to be something about it that will be remembered, and (3) it has to hold our interest. That pleasurable tingle we mentioned earlier—a sign from our emotional system—only happens when these three things are present.

Building on Gardner's third point, maybe beauty has something to do with our personal passions? There are some things that we like that seem to stay around for a long time, and that we can't get enough of. But are we getting ahead of ourselves? Let's explore beauty more deeply and see if we can get to the root of what the experience of beauty means to each of us.

[Your Thoughts]

Idea 1: There's a direct connection between our senses and beauty.

The way that we learn and grow is through experiencing and interacting with our environment. This begins with our senses. If there is no information coming into our mind, then the mind would be mindless, that is, it wouldn't have any resources to construct itself! Fortunately, our bodies are built to experience life.

When we as human beings think about our senses, we generally think of the five senses of physical form—seeing, hearing, tasting, smelling and touching. Since most of us are fortunate enough to use those senses regularly as part of everyday living, we know how they work. For example, if something you are eating doesn't taste good, you spit it out. If you're trying to read and it's dark, you turn on a light.

We also have two powerful "inner" senses, which increasingly come into awareness with maturity, that are a very important part of our everyday experience. The first inner sense is located in the heart center and has very much to do with our connectedness with others. The heart has long been associated with compassion and love, which help us deepen our connections to others. A truth that most

of us will recognize is that we are social beings. We *need* other people in our lives, and our lives are the richer for those experiences. Helen Keller, who was both blind and deaf, recognized the beauty of these connections when she shared, "The best and most beautiful things in the world cannot be seen or even touched—they must be felt with the heart."

The second inner sense is located in the crown, right at the middle of the top of our head, that soft spot that begins to close shortly after birth. This sense connects us to the larger whole, whether we perceive that larger whole as the ecosystem of the earth, a global humanity, an energy field, a consciousness field, a quantum field, the God field, Heaven, or any other variety of names. Whatever your belief, we as individual human beings are part of something larger, and, if we listen carefully, we can sense that larger field of which we are a part. For example, in the religious experience we may pray to God.

Now, let's explore the understanding of our senses a bit more. All of these seven senses can be looked at in terms of our physical, emotional or mental focus. Think about it and it makes sense. You operate in the physical when you walk or talk, or when you hit a baseball out of the field for a homerun! But that walking or talking or baseball hitting wouldn't happen if you didn't have a mind to direct those actions, and how much fun would it be

to hit a homerun if you (and your family and friends) didn't get excited about it?

Information is continuously coming in through all of our senses in each of these focus areas. For example, seeing from the physical refers to the physical qualities my eyes are viewing, seeing from the emotional focus refers to the emotions or feelings emerging from what I am viewing, and seeing from the mental focus refers to the connections I am making of what I am viewing to what I already understand. In total, that's 21 sensing ports which, for those of you who enjoy mathematics, means that there are 51,070,942,170,709,440,000 different potential combinations of incoming information. That's a lot of information processing!

Fortunately for us, a lot of that processing is done in our unconscious, that is, outside the awareness of our conscious mind. *Conscious* thought is the thought that we hear within, and speak without, of which we are aware. All this is pretty fascinating. I just bet you never thought about all that information power *you* have available!

Why is it important to understand our sensing capability in this conversation about beauty? Okay, yes, there is a very important reason.

Remember the earlier conversation about everyone's beauty being different? Well, that's true. *Your* experience of beauty is very different than your friend's experience or my experience. Yet there is an

overarching pattern … or maybe you can think of a better word than "pattern" to describe this phenomenon. And here it is: when *you* are experiencing beauty, it is the most important thing in your mind; in fact, it is the ONLY thing in your mind! The full experience of beauty engages ALL your senses in ALL three focus areas. There's no room to be thinking or feeling anything else! Close your eyes and remember this kind of experience, and you'll see what I mean.

The experiencing of beauty is a "now" experience. And if you are fully engaged in the "now" of beauty, then there's little room for any of the negative energies from the past and present that periodically, and sometimes regularly, hang onto us. Let this idea soak in for a few minutes.

<<<<<<<<>>>>>>>

INSIGHT: **The experience of beauty is a *now* experience … if you are fully engaged, there's little room for any negative energies from the past and the present to hang onto us.**

<<<<<<<<>>>>>>>

There are, of course, other good reasons for us to understand our sensing capabilities. One simple reason is that when we understand the way our "self" works, it helps us understand why we think or feel (and therefore respond) certain ways in certain situations. For example, when we understand that

much of this processing is done in our unconscious, it helps us understand how we know certain things when we don't remember learning them or previously experiencing them.

Let's say you're having a conversation with a friend who is sitting on the porch while you are simultaneously planting a flower, swatting a fly away from your head, blinking away the bright sun, feeling the cool earth in between your fingers, enjoying a soft breeze, hearing kids arguing in the distance, all while staying consciously focused on the conversation with your friend! Yet, later that afternoon, when a neighbor tells you those children were fighting with each other, you immediately respond that they successfully solved the issue among themselves, and did a pretty good job of it. And, until that conversation was "triggered" you had no memory of the incident!

Another good reason is to realize how much *you* are capable of processing. The limits you place on yourself—perhaps defining yourself by lacks in terms of experiences such as traveling, educational opportunities, social relationships, etc.—are self-imposed. While the choices you make in life certainly impact your growth and learning, through the process of living you have gained innumerable experiences. In other words, you KNOW a great deal more than you know you know. And that's important to understanding the amazing person you really are.

Sometimes it's helpful to set up a contrast to help understand a thing, and certainly the idea of beauty seems to be directly opposed to the idea of, say, war. There are different ways to think about this contrast. For example, physicist Niles MacFlouer says that in order to achieve beauty in the physical world, you need to reduce conflict. Forces we create destroy beauty. This certainly makes sense. For example, consider the great works of art (architectural books, paintings, sculptures) that were destroyed during World War II.

As an example, in today's world Niles uses the Israeli's use of force in an attempt to counter forces being used on them, and vice versa, as an example. This, of course, is called war, and the reason it is unlikely to resolve any issues is because war has the immediate effect of destroying the senses (desensitizing us) and *uglifying* the environment that you are using force against. So, not only is art destroyed during war, but the appreciators of art are desensitized, and the artists, creatives and intellectuals are murdered and imprisoned … they are considered dangerous since art and beauty have the power to inspire revolutions!

The award-winning children's book artist, Jackie Urbanovic, looks at this relationship between war and beauty from a different frame of reference. She says that there are times when under the duress of destruction, worry and loss that our sense of beauty is heightened. For example, the sight of a single

flower in the debris or the helping hand of a stranger can lift our spirits, literally blossoming into a beautiful experience. Nowhere is this clearer than in the work of Viktor Frankl, who discovered moments of love and beauty of thought in the midst of the horrors of Auschwitz.

Beauty can become more important during difficult times because it reinstates hope. Further, Jackie says that memories of intense, negative experiences can also lead to the creation of art as a way to understand and transform those experiences from destructive to meaningful, and even beautiful.

From the viewpoint of our senses, beauty is something good, pleasing, attractive and satisfying, a combination of qualities, impressive to touch, feel, look at, taste, smell, listen to and think about. When we introduced the senses near the beginning of this book, we forwarded that beauty enhances and unifies the senses in our body and in others. As we reflect on the beauty of what we see, our thought becomes more beautiful and we express this to others, helping them see beauty in relationship to their own personal experiences. When this happens, the field of thought of which we are a part is lighter, and everyone enters into the experience of beauty!

Beauty enhances and unifies the senses in our body and in others. This may begin with a single sense recognizing beauty and then spreading to other senses, that is, if we "see" something that resonates

with the beauty—perhaps a painting that engages us with color and triggers memories and inspires our thinking—it is connecting to memories in the past, with the potential of engaging additional senses.

<<<<<<<◇>>>>>>

INSIGHT: **Beauty enhances and unifies the senses in our body and in others.**

<<<<<<<◇>>>>>>

Dave Austin—a motivational speaker, former professional athlete, and sports coach of a U.S. Olympic team—shares a story about when he was swindled by a business partner. He felt quite unforgiving for a very long time! Then, one day when he was in China, a place of great beauty, in the midst of that beauty he all of a sudden experienced a feeling of complete forgiveness.

There is no doubt this is one of the ideas behind *Feng Shui*, which was developed in China about 4,000 years ago and was originally linked to the land and rivers (*feng* is wind, and *shui* is water). Today, millions of people use it to live in harmony with their environment and create abundance and prosperity. In *Feng Shui*, beauty is created via balance, which reflects the trade-off between, or a balanced integration of, the five natural elements (fire, water, metal, wood and earth). When you take a look at the beauty of a Japanese or Zen garden, you begin to get a feel for this balance.

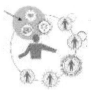

Idea 2: Thought is living energy, an iridescent light of marvelous colors, forming and reforming and manifesting into reality.

This is a powerful statement that can certainly sound confusing! It seems to talk about thoughts as if they are things taking some sort of form. But aren't we really talking about the *content* of our thoughts, whether they are good or bad thoughts, ugly or beautiful?

Woah! That's a lot of ideas to talk about all at once. We'd better tackle this a bit slower, maybe taking it a bite at a time. First, let's see if we can agree on what thought is … then we'll look at thought as beauty *and* the beauty of thought, which are two different perspectives for exploring the relationship between beauty and thought.

What is thought? From the physical perspective, everything is energy and patterns of energy. Everything. So, in the context of this conversation, thought is a pattern of energy produced by an individual human brain and mind, like yours. We say *brain* and *mind* because the brain is the physical structure and the mind is the neuronal connections and firings that occur in that physical structure. And, while all we've just said is true, it

really doesn't tell us much about thought as we think about it.

A simple way to think about thought is as a product of thinking, reasoning or imagining, that is, mental activity. But, again, what does that really say? It's hard to define something by the process of producing it. Have you ever realized how hard it can be to define something that you have all the time?

So, let's see, as a noun thought might be considered an idea, belief, reflection, opinion, view, consideration, purpose, intention, expectation, concept, memory, persuasion, judgment, sentiment, and probably dozens of other similar concepts! From all that, what we can now say is that "thinking" is a process and "thought" is a product of that process, a focus on something.

What we have learned more recently from all the research that's been underway in Neuroscience since the turn of the century, is that our thoughts (what we are thinking about) can change the structure of our brain! And, in a circular relationship, the structure of the brain affects our thoughts!

While this is a simple relationship, it seems to beg the questions: So how can we change? Are we ever destined to think the same kind of things over and over again? No ... because we have choice.

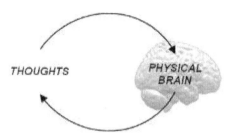

Figure 1. *Changing our thoughts changes the structure of our brain, and the structure of the brain affects our thoughts.*

Now we can think about thought in another way. Since we can *choose* what to think, that is, we can choose our thought, then thought can be considered *a combination of choices*, connecting one choice to other choices previously made, and affecting future choices. This means that every thought that comes in from our environment is connected to (associated with, interpreted by) all the other thoughts (choices) we've made in the past!

Let's think up an example. I walk outside for a short jog and note dark clouds rapidly approaching, maybe even seeing traces of lightning. My thought is, "storm coming" and, since I don't like getting caught in the rain, my thought continues, "not a good time for a run" or, perhaps, "take an umbrella." All of those follow-on thoughts are based on earlier thoughts and experiences, earlier choices that defined my preferences. Pretty interesting how our mind associates things in the present environment

with things from the past, all of which help us make good decisions for the future.

<<<<<<<<><>>>>>>

INSIGHT: **Thought is a combination of choices, connecting one choice to other choices previously made, and affecting future choices.**

<<<<<<<<><>>>>>>

The Dalai Lama has beautiful words to assist us in understanding that we change things from the inside out. He says very clearly that, "In order to change conditions outside ourselves, whether they concern the environment or relations with others, we must first change within ourselves."[1]

So, how are **Thought and Thought Forms** different? A favorite idea I really like to reflect upon is, "The material word is an effect, not a cause." I've had a lot of fun with this idea when interacting with my scientist husband. He is VERY pragmatic, and through our early years together often said, "I'll believe that and act on it when I see it happen."

Quite to the contrary, we're now beginning to understand that's not the way thought works. Thoughts are so powerful that energy follows them and they become thought forms. This means that the human mind controls energy and builds form! These are not heavy physical forms, but made up of patterns of energy of emotional-mental matter. Remember, we exist in three focus areas: physical,

emotional and mental, so we have the capability of interacting with our senses in all three of these focus areas, both sending out and receiving information (energy patterns).

When we send out thought forms into the environment, they actually attract similar thought forms. Now, this can be very hard to understand for those who want to see everything at the physical level! Still, remember, as we learned earlier, our Neuroscientists have now discovered that our thoughts change the physical structure of our brain.

Thought as Beauty. This is looking from the outside of the thinker at the thought being manifested. I told you we'd get to this discussion!

When you have a thought that is definite there is a double effect, producing both a floating thought form *and* a radiating vibration. Further, each thought form differs in both density and quality! Researchers in this area have been able to identify color, shape and a distinctness of outline in thought. Color has to do with the emotional quality of the thought; form has to do with the intent of the thought; and distinctness of outlines has to do with the degree of concentration of the thought. That radiating vibration is a complex one to understand. What's really fascinating is that every rush of feeling associated with thought produces a permanent effect.

To truly appreciate thought as beauty, we look to the words of Annie Besant, a British socialist and

women's rights activist, and Charles Wester Leadbeater,[2] who was a liberal Catholic bishop and Theosophical author. Evidently, they both were quite accomplished writers. Their descriptions of mental thought certainly reflect that skill:

> The mental body is an object of great beauty, the delicacy and rapid motion of its particles giving it an aspect of **living iridescent light**, and this beauty becomes an extraordinarily radiant and entrancing loveliness as the intellect becomes more highly evolved … Every thought gives rise to a set of correlated vibrations in the matter of this body, accompanied with a marvelous play of color, like that in the spray of a waterfall as the sunlight strikes it, raised to the n^{th} degree of color and vivid delicacy.

Figure 2. *Thought into form … YOU!*

Interesting examples are thought forms built by music. While sound is often associated with color, it also produces form. Annie and Charles discovered an infinite variety of thought forms they thought were very striking and impressive that were built by music. They say that different types of music have different forms, and that "the style of the composer shows as clearly in the form which his music builds as a man's character shows in his handwriting." Wow! Reminds me of a music appreciation class from many years ago where the instructor would play a short piece of music and ask us who the composer was.

Well, these music thought forms also look different depending on the kind of instrument being played as well as the merits of the player. Yet, the *same* thought form occurs when the same piece of music is played accurately! That wouldn't happen for me. I never really became very good at playing the piano.

Beauty of Thought. There are two levels of mental thought: logic, built on an understanding of cause-and-effect relationships (that's lower mental thought) and concepts, which emerge from repeated patterns (that's higher mental thought).

Think about it this way. When we are young, we learn patterns of behavior by being rewarded and/or punished. If I study for a test, I get a good grade. If I don't, more than likely I'll fail, and my parents will

be pretty, well, upset with me. When I'm older, I get a pay raise when I do a really good job, and lose my job if I mess up. You get the idea. That's lower mental thinking based on cause-and-effect.

Now, when I begin to recognize patterns, that is, over and over again I see that when I work hard at something, give it my all, that I really get some pretty good rewards, then I've developed a concept, which is higher mental thinking. Now I'm no longer reliant on the past to develop an understanding of what will happen, but have *recognized a pattern*, which I can use to "predict" the future response to my actions. So, with the recognition of patterns comes the ability to make better decisions about the future.

Further, this recognition of patterns helps me discover larger truths. For example, let's say I recognize that studying helps me get better grades as a pattern. However, in one situation I study and still get a low grade! So, I take a closer look, and figure out that I wasn't paying attention in class and wrote down the wrong assignment for test preparation. Oh, dear! So, it's not enough to just study, but rather to ensure you are studying the *right* material! I've now achieved a higher concept which has higher truth, understanding more about how things work together. The more concepts we're able to connect together the higher the truth of our understanding!

However, if I go back to lower mental thought, that is, thinking that all I have to do is study, then no doubt I'll repeat the same mistake over again. Lower mental thought forms diminish the capacity for higher thought forms to function. We get caught in them and think we're doing just fine, and that attitude affects my ability to create higher thought forms. This is because thought forms linked through logic limit the ability to perceive the larger truth of conceptual thinking.

Have I confused things? If so, maybe go back and read the last five paragraphs again. And remember when you were studying for a test, way back when, or maybe more recently? Think about all the other things that could impact your results, things like getting enough sleep. All of the things that contribute to your success are part of a larger concept called "success." Now, think of all the other concepts you've put together through your life experiences. You have a concept of what it is to be healthy, a concept of how to act in a relationship, a concept regarding what it is to be a good friend, etc. And all of these concepts, made up of patterns, have been developed by you *for* you, to help you navigate the world!

While the thought form is clearly a product of the thought, with the energy of the thought form animated by the idea that generated it, there is more beauty of thought to be recognized as we begin to understand the thought itself, connecting and

integrating it through our own senses. Remember our conversation about each person's perception of beauty being different? Well, beauty of thought is going to be highly dependent on an individual's areas of passion.

For example, Nobel physicist Paul Dirac spent his life searching for beautiful equations; the beauty of an equation was more important than its usefulness! Paul saw the essence of this beauty lying in the economy and elegance that brings to the surface the mathematical property of being deep. You may have heard someone talk about mathematical beauty, and how over and over again, equations with mathematical beauty successfully describe the nature of the physical world.

$$E = mc^2$$

Figure 3. *Albert Einstein's elegant equation of special relativity expresses the sameness of mass and energy, which describes the nature of the physical world.*

What kind of thought do you see as beautiful? Have you had this experience in your life? If you have discovered this secret about yourself, then you have a key to changing your thoughts when you choose to do so, dispelling negative thoughts that eat up your energy, and bringing more beauty into your life!

Idea 3: The aesthetic has the power to mold our thoughts and alter our perceptions.

That word "aesthetic" gives me pause ... it's an unusual word that houses a great concept! And, that concept is beauty! Yep, "aesthetic" is another way of saying "related to the beautiful." Specifically, we could say that something that is aesthetic is a work of art that expresses great beauty. Some people even refer to aesthetics as a philosophy or theory of beauty.

As a global world, we've made enormous technological, economic and genetic advances that have both elevated and troubled our minds. In the midst of this expansion, the aesthetic has taken a back seat. Yet, since thoughts change the structure of our brain and the structure of our brain affects our thoughts, aesthetics has the power to mold our thoughts and alter our perceptions!!!

Art has the potential to enrich human life in so many ways. There's a freedom that comes with art; the only limits are our imagination and ... well, I guess you have to have a bit of talent as well!

Art is symbolic, conveying so much more than what is seen on a canvas. There can be layers and layers of meaning embedded. A glorious work of art can surface a deep emotive response, connecting the

observer or listener with long-term inner memories and feelings. A great work in the visual arts can lead the viewer to new ways of seeing and acting.

<<<<<<<><>>>>>>

INSIGHT: **Art has the potential to enrich human life in so many ways.**

<<<<<<<><>>>>>>

Although we don't generally consider it as such, even our written language is comprised of symbols. The 2017 movie *Arrival* provides us a language lesson, where alien symbols are translated outside time by linguist Louise Banks.

While the limits of time still prevail in our world, the symbols of language flow among a global humanity in unfathomable numbers. When eBooks and hand-held devices became the norm, it was predicted that hard-back books would disappear. Indeed, several large and well-known bookstore chains like Waldenbooks and Crown Books closed their doors. However, according to the U.S. Census Bureau, 2016 figures for book sales increased. In the January-June 2016 time-span, sales totaled $5.44 billion up from $5.13 billion in the same time period in 2015, a 6.1 percent increase.

The renaissance underway in literature appears to expand to all the arts. In major cities there is an increase in theater attendance and sports events, and more people going to museums. In the U.S., the

number of live theater visitors has steadily increased since a low in 2012. Spring 2015 figures show 47.42 million visitors, up from 46 million in Autumn 2014.[3]

The *Art Newspaper*, which does an annual survey on exhibition and museum attendance, consistently touted large numbers of daily visitors to special exhibitions held around the world. Nine exhibitions held at Taipei's National Palace drew in over 12,000 people a day. A Monet exhibition held at Tokyo's Metropolitan Art Museum drew in over 10,000 people a day. While some museums surveyed had lower regular attendance due to reported local difficulties, London's British Museum, which is free, pulled in 6.8 million visitors in 2015, over 100,000 more than in 2014. Even the Louvre in Paris, despite November 2015 terrorist attacks on the French capital, pulled in 8.6 million visitors, only 600,000 less than in 2014.

Art can also lower our energy. Not all art generates experiences of beauty. Reflect for a moment on the art of today, much of it projecting ugliness and dissonance in a search for difference or expanded repetitiveness. Concerts featuring repeats of the great works of music. Remakes of movies, failing to capture the beauty of the original, with added elements of violence to grab attention. Reality shows. Reruns of reruns. When we interact with these, we are pulled into a frame of reference that focuses our attention away from the meaning and

purpose of our own lives. However, we do have choice. Since the arts are dependent on stimulation of the senses, if people refuse to sense it the art goes away. As a discipline, we can simply turn our senses off to this media, and turn our attention to something better. *We have choice.*

Beliefs have inspired glorious works of art across the span of music, architecture, sculpture, painting, literature and dance. For example, the powerful influence of mythology on human intellect and emotions has led to the creation of magnificent art. The black figure vases of ancient Greece have images of mythical characters on mythical journeys. Of course, belief in myths is just one source of inspiration. And then, that which is inspired serves as inspiration for others!

A number of artists periodically dance with their art in the middle of the Allegheny Mountains of West Virginia which is Mountain Quest. For example, Corbie Crouse—a former Walt Disney World artist who taught guests how to draw Mickey, Donald and Rapunzel—lives in Orlando, Florida, what she describes as a "populated environment with many distractions." Every year she and her husband come to West Virginia and stay at the Inn. One of her pictures is on the back cover of this book. As Corbie shares:

> *The atmosphere is beautiful and quiet. The environment brings us great peace, allowing my*

creativity to expand in ways that are new to me. The watercolor paintings I create at Mountain Quest have a boldness and surety to them that is rare for me. These new creative experiences help me to grow as an artist and a person.

Hmmm. This introduces the beauty of place as art. That's certainly interesting. We'll come back to that.

As we move from conversing on art as beauty to exploring the extraordinary connection between beauty and love, you might enjoy a different frame of reference shared by poet Cindy Lee Scott. She calls this "Aperture to the Soul."

Looking deep into the eyes
Seeing light beyond the face
Immersed in the sea of life
Connecting to the human race.

Oh, responsive persona
Gazing into what is true
Finding reflective beauty
Perceiving the life force in you.

-Cindy Lee Scott

[Your Thoughts]

Idea 4: Beauty is love made visible.

These words were expressed by Reefka Schneider,[4] one of the foremost artists of "la frontera," the binational region of the Rio Grande Valley in South Texas. Reefka's electromagnetic sensitivity found relief in the natural setting of Mountain Quest, her *sanctuary in time and space*.

One of Reefka's paintings is on the back cover of this book. As Reefka describes,

> *I would rise before the sun did so I could paint the silence and color of early morning. Later I would climb the mountain and paint, perhaps observed by a red fox or young bear ... At Mountain Quest I experienced the singular beauty of the spontaneous statement that small watercolor work provided me as I attempted to capture the feeling of the soul of the place, that transcendent connection to the inner life that is both silent and beautiful.* (Reefka)

Reefka is right. Beauty is love made visible. But I think the way she uses the word *visible* means more than just seeing something with your eyes. It seems to have a larger meaning. In this context, I think it means "known." You can know things by seeing them, but you can also know things by feeling them, hearing them, tasting them, touching them,

connecting with them, and, well, just by knowing them … Hey! We're talking about those seven senses we all have! All of our senses provide ways of knowing. That's a pretty good idea we just came up with.

Now, Plato believed that the love between two people was a stepping stone to love between souls, and then an opening to *ideas* and *philosophy*. As Plato says in his *Symposium*,[5] "… the lover is turned to the great sea of beauty, and, gazing upon this, he gives birth to many gloriously beautiful ideas and theories, in unstinting love of wisdom." When love is an attachment between two people, the very act of gazing upon the beloved, "the great sea of beauty," gives birth to beautiful ideas and theories. With the attachment of love, observing beauty leads to more beauty!

This relationship between love and beauty bears more thought. What do you think about it?

* * * * *

EXERCISE: *Opening your Heart Space*

This exercise requires a partner who can be another person or, with a little imagination and empathy, a beloved animal friend. When working with another person, make sure the two of you have already developed a relationship of respect and trust, whether in a work or personal environment. Ask

your partner to imitate your actions as you move through this exercise.

STEP 1: Sit comfortably on two chairs facing each other, feet flat on the ground, your torso leaning a bit forward with your palms (fingers down) gently leaning on your knees.

STEP 2: Loosen your face muscles and release any tension you may feel. Allow a soft smile to ride on your face as you look into the eyes of your partner.

STEP 3: Notice the color of the eyes, comment on that color. Notice the light *behind* the color, how there seems to be some energy reaching out toward you. Now, close your eyes and imagine that light reaching all the way to you. What color is it? Can you feel its warmth?

STEP 4: Now, still with eyes closed, slowly imagine the energy moving downward from the eyes towards the heart space, and gently filling that space. The two of you are now connected at the heart.

STEP 5: Imagine that connection. What does it look like? Feel the flow of energy between the two of you. Focus on that energy, remaining in that focus for several minutes.

STEP 6: Open your eyes. See and feel the beauty of your partner, thanking each other for the experience. REFLECT on your feelings.

* * * * *

[Your Thoughts]

Idea 5: Health is a work of art.

Your physical body—along with your emotional and mental bodies—is *your* creation. In order to be beautiful, we must become healthy. We all understand that what we put in our bodies is important, that is, what we eat and drink, and the air we breathe. We also understand how important it is to exercise our bodies, and that how we use our bodies impacts our wellness.

What many of us do *not* realize is that what we think and how we feel also directly impacts our bodies. For example, when you are under stress how does your body feel? You may suffer headaches or an upset stomach or even have a stroke or heart attack.

Long before Neuroscientists understood the power of thoughts, Prentice Mulford,[6] a 19th century literary humorist and author, recognized the impact of your thoughts on your body. As he described,

> Your thoughts shape your face, and give it its peculiar expression. Your thoughts determine the attitude, carriage, and shape of your whole body ... **The law for beauty and the law for perfect health is the same. Both depend entirely on the state of your mind**; or, in other words, on the kind of thoughts you most put out and receive.

[I added the bold part to that quote because it is so important.]

Note the relationship between beauty and perfect health. Prentice said that the prevailing mood of mind affects both the health *and* looks of the body. That which you think most you become. If your thought is determined and decided, your carriage and movement show it. If you are cheerful, your face will show it. So, as Prentice discovered so many years ago and we are just now believing, "Persistency in thinking health, in imagining or idealizing yourself as healthy, vigorous, and symmetrical, is the cornerstone of health and beauty."

Health is a relative concept denoting a physical, mental and emotional state of being. Gosh, we use that word "relative" quite a bit. And, no, we're not talking about anyone you are related to! In this context, relative means that something changes depending on, for example, its environment, or the situation it is in.

The way we are using it, it has to do with the level of functioning and metabolic efficiency of our particular body as a living organism. While we must be healthy to be beautiful, *health is a state internally created through the creation of beauty*. That's such an important thought, let's put it down again as an insight.

<<<<<<<<>>>>>>>

INSIGHT: **While we must be healthy to be beautiful, health is a state internally created through the creation of beauty.**

<<<<<<<<>>>>>>>

Now, you can't *create* beauty by periodically going to a gym or eating well. Developing a foundation for health requires a *consistency of choices*. There are internal drivers such as feelings, beliefs, values, past experiences, etc. that manifest in the physical that drive our choices. When you get down to it, your choices in food and even who you consult for your health care require mental development, unusual fortitude and great wisdom! A negative example that impacts choices is stress; a positive example that impacts choices is the use of positive thinking.

An interesting example that eventually affects most of us is aging. The concept of aging is one that has been culturally and globally adopted. However, physicist Niles MacFlouer says aging as a yardstick is an illusion. As he describes, beauty in body is not aging by the standards of today. If you use that standard, aging means that everything is breaking down.

Nile's definition of health is the ability to develop an on-going state of wisdom while *living longer and longer without the signs of aging*. There

are many doctors who agree with him. Whatever your age, if you live a "healthy" lifestyle (physical, mental and emotional), aging will slow down. The more beauty created, the slower the aging process.

Of course, beauty of the self is in producing health in *all* of our bodies, and that includes your physical, emotional and mental bodies. From this frame of reference, there is beauty in aging. For example, often the aged, more experienced mind is more content, focused and calm than in youth.

Remember Jackie Urbanovic, the children's illustrator we introduced earlier in this book? Well, she describes aging this way:

> I am focused on different priorities and I've come to enjoy the difference between the beauty of youth and its intense sexual passions, its desire to be everywhere at once, the joy of beginnings and, with older age, the increased focus, gained wisdom, and greater sense of security and self. ***Like art, aging is difficult, revelatory and beautiful, all at once***.

While health is intended as the natural state for the human, for most of us this is not the case today. To a large extent, being unhealthy is a product of today's life style, as evidenced by the propensity for people to be overweight … eating things that are bad for our bodies because of accepted food processes or because we are in a hurry.

Ultimately, it all comes down to the choice of what we *think, feel and do*. Beauty is a choice.

* * * * *

EXERCISE: *Choosing Beauty*

STEP 1: If you have one of those watches that has an alarm on it, set it to go off on the hour every hour. If you don't, go about your day checking your watch regularly. When the alarm goes off, or when it is close to the hour, turn the alarm off, stop whatever you are doing and go to Step 2.

STEP 2: Slowly turn completely around, scanning those things that are close to you, say within five or six feet. Spend a moment thinking about each of the things that come into your view. About each, **consider:** How is this useful? Who created this? Does it serve a purpose? Do the pieces all fit together well? Are the colors pleasing? Allow yourself to be fully in the NOW; FEEL into the item upon which you are focusing. Allow each item their moment of importance.

STEP 3: Slowly take a second complete turn, this time focusing further out into the distance, reflecting on all that comes into your view. If you are outside, you may wish to take a third turn to reflect on the far distance. Give every item its special moment in time.

STEP 4: Closing your eyes, consider all of the things you have brought into your focus and how they all fit together. Imagine yourself as the model in a famous artist's painting, with all of the things around you of significance to the painting. What story do they tell? What is your relationship to these items? What do these things that surround you tell you about the figure in the painting, that is, YOU.

STEP 5: Take a leap into the future, say 100 years forward. Using your creative imagination, picture yourself in the middle of an art auction, and there in front of you is the picture of YOU and all those things surrounding you. Many people are bidding, and the price gets higher and higher. As people keep bidding, you look closely at the painting, and you begin to see *why* they are bidding. There is a relationship between the person that is YOU and all those things that surround you. They look REAL and yet there is an invisible energy that says more than the picture. You look closely at your face, captured with the eyes closed, and see a wonder expressed there. You note that the artist has captured the knowing that is occurring in the moment at hand, that even with the eyes closed this figure has *full awareness of who they are and where they are*. The bids continue to go higher and higher.

STEP 6: Still in that place, you hear the auctioneer pause and say: Is there another bid? This is a *Carlotti*, a special picture. The summation of the parts work together in such a way that nothing needs

to be added, taken away or altered. He has captured a perfect life moment.

STEP 7: Still in that future place, push your hand into your pocket and pull out a credit card with no limits, recognizing that in this place you are wealthy and have the means to purchase this painting if you choose. Do you choose to do so?

* * * * *

[Your Thoughts]

Idea 6: Beauty is a multiplier of life experience.

When focused outward and shared, creative energy multiplies. Let's explore that idea from the viewpoint of knowledge. Knowledge is when you as a decision-maker have information, act on that information, and get the desired outcome, or at least an outcome that is heading you the direction you desire! After all, our world is pretty complex, and it's pretty easy for things to get in the way. So, I figure if you are heading in the right direction, that's pretty good.

This is what the Greek philosophers meant when they defined knowledge as *justified true belief.* You have a belief that you act on, and it is justified as true because you get the result you expect. Today, we describe knowledge a bit differently because we understand that we make decisions and take actions based on more than our beliefs. I mean, *most* of us take into account our values and past experiences as well. So, the definition of knowledge we use today is something like, *the capacity to take effective action.*

Now, when we have knowledge and we share it we actually multiply it! I know this sounds a bit strange. If you have a piece of cake and you share it, then you only have ½ piece of cake left to eat. If you have a coat and you share it, well, it may not be big enough to cover two of you. On the other hand, if

you get really close there IS a lot of body heat! So maybe that's getting closer to the idea of knowledge sharing. Body heat can get a whole lot warmer than wearing a coat!

Back to knowledge. Lots of wonderful things happen through knowledge sharing, cooperation and collaboration. First, as we all know, you can tackle bigger issues when you have a couple of people collaboratively working together. For example, maybe you've done a group project in school, or maybe you've played doubles in tennis, maybe you've done group quilting, or maybe you've been part of a good baseball or basketball team, where everybody's skills count.

On a personal note, as we interact with others we develop a deeper understanding of others—and a deeper understanding of ourselves in relationship with others—and we begin to really appreciate diversity. Think about that basketball team interaction. Yep, no doubt you can do something really good, but maybe your strength is in layup shots, so you stay available, and since your teammates know you are really good at layups, they set you up. Someone else may be an expert at taking foul shots. Heck, you may have someone on the team that makes perfect shots from half-court. So, you're going to want to make sure he has the opportunity to do that! Playing team sports, you develop a real appreciation for diversity.

I think this is what is meant when people say the whole is greater than the sum of the parts. I mean, the way a team works together to take advantage of everyone's special skills—and everyone *does* bring something special to the team—which makes the whole team perform better.

Remember how we started this conversation? We said: When focused outward and shared, creative energy multiplies. This is because we are all creative. Yes, you are creative, even if you don't think of yourself that way! The first step you took as a baby was creative. The way you developed your writing was creative! In fact, the first time you do anything different is a creative act. That's what we call P-creative. (The "P" stands for personal.) Okay, so you're not the first person to do it, and you're not necessarily the one that is remembered in our history books for doing something first. But it's still a creative act.

And here's the thing. Creativity is the bisociation of two or more ideas to create a new idea or apply an idea in a new context. That's a pretty good definition. More simply stated, a creative act is putting two things together in a new way. Of course, as we now know, everything starts with energy. Information is a special form of energy, which when effectively applied is knowledge. Then, combining our knowledge and creativity and connecting ideas with a need or opportunity leads to innovation.

Reflect on this:

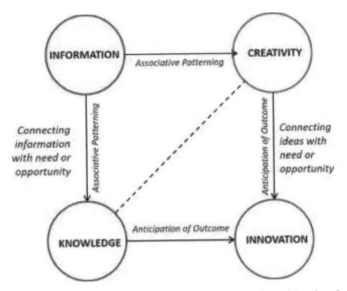

Figure 4. *Information is the basic building block of energy that informs knowledge and creativity.*

When people share their ideas, think of all the creative potential! Ideas are put together by creative minds in different and unusual ways to develop new and exciting and beautiful thoughts, all waiting to be put in service to an interconnected world.

This sharing of creative energy extends to the creation of beauty, whether a book, a painting or sculpture, or even creation of our *self*. And when we create with others, there is an expansion of our

"creation juices," just like what happened with the basketball team.

Admittedly, the creation of beauty has become harder through the past century as we embrace an artistic cycle of repetition and, in an attempt to grab attention, extremes are tapped over and over again, often resulting in negative experiences. It *is* difficult to take a play from the past and come up with a new creative approach that grabs the minds and hearts of today's audience while staying true to the message and intent of the work.

You might even have heard someone say, "Everything's been done … and different is not always a thing of beauty!" However, there is *always* something new in the experience of living. There's that P-creativity again!

<<<<<<<◇>>>>>>>

INSIGHT: **There is *always* something new in the experience of living.**

<<<<<<<◇>>>>>>>

We don't have to be a great artist to create and share beauty. We *do* each have the opportunity to beautify our environment, and if we have a stream of people moving through that environment, we are sharing that beauty and helping others to improve their senses. This may begin with members of our family, then extended family and friends, and even carry over to a larger group.

If the people you interact with have values that are similar to yours, then the beauty they discover in your shared environment moves on to others, that is, they are creating beauty in their thought as they immerse themselves in the beauty of the environment, and have the opportunity to share that thought with others! Think about a good storyteller sharing their latest vacation with you, complete with all the emotion and humor that laced their experience.

So, beauty is a multiplier, with each of us serving as an example for others. By creating a beautiful environment and sharing it, we are advocating beauty in the senses of others ... and as we are beginning to see, beauty supports the growth of all parts of life. When we understand this, it is our job to create environments that affect more than ourselves so that others can experience beauty in those environments. This is what we do when we plant gardens and when we designate natural sites as National parks. Sharing the beauty of our environment is one of the few ways that we can, on a daily basis, directly see the results of our actions.

<<<<<<<◇>>>>>>

INSIGHT: **By creating a beautiful environment and sharing it, we are advocating beauty in the senses of others.**

<<<<<<<◇>>>>>>

An example of sharing beauty is the creation of Mountain Quest. My partner, David, had a dream that he built a research and retreat center, so we set out following that dream. The intent was to create a place of beauty in a natural setting, designed with the thought in mind of elegant simplicity or simple elegance. Yes, there is **beauty in the setting**, with vibrant green fields set in a high valley of the Allegheny Mountains punctuated with trees, streams and wildlife.

Beauty in the experience is supported through themed rooms, bringing in a taste of international diversity and some favorite areas of interest and passion. For example, there is a Play House, with heavy rich red and gold brocades like in a theater at the turn of a century, a golden punched tin ceiling (which was spray-painted in an auto body shop), carved poster mahogany beds and souvenirs from plays and musicals. There is a Nautical Cove that has a full-wall mural of a dock in Southeast Asia (painted by a retired Navy Chief), with two beds tied up to the dock. Of course, one of the beds is a water bed. You get the idea.

Then, **beauty of thought** is honored and encouraged, with a two-story, 27,000-volume library, which shares the thoughts of well over a hundred thousand authors! Then—for those with open minds and hearts—there is the phenomenon of the *Myst*, which represents a deeper look into the natural energies that surround each and every one of

us, energies that are often invisible and that rarely capture our conscious attention.

There is also a **beauty of gifting** so that others can enjoy. Lots of people who visit Mountain Quest bring a piece of themselves into the rooms and common spaces. For example, books for the library from a naturalist whose sight was waning, a family picture of a 1940's bomber for the Hanger Room from a WV state employee, and five older goats raised by 4-Hers for visitors to enjoy.

This beauty thing really is catching. Other things of beauty keep coming into my mind. For example, there's also the **beauty of connecting** … whether that means reading in the library, sharing conversation over the breakfast table, rocking on the front porch, feeling the soft breeze off the mountains, or just watching the gentle grazing of horses.

Hmmm. Beauty seems to have an immediate effect that involves all the senses; it is seen and felt inside and out. By taking the time to separate from a busy and often overwhelming and troubling life to experience new places, join in new conversations and connect with nature, life can take on an entirely different meaning, or bring back purposes and directions that have been pushed to the edge of our thought.

Yes. I *feel* it now. Beauty is a multiplier of life experience.

Idea 7:
Beauty is transcendent.

Every once in a while, you really have to give it to those philosophers! They knew what they were writing about. In that *Symposium* piece that Plato wrote—the one we talked about earlier—we're told that the beauties of the earth are to be used as stepping stones moving humanity upwards through fair forms to fair practices to fair notes and, ultimately, to absolute beauty, which Plato described as fair living.

This word "fair" seemed to have a lot of play in Plato's words, I mean, he used it a lot. So, it must be a pretty important concept. What does that mean to me? Maybe related to words like honesty, truth, right, reasonableness, impartiality, just … maybe representing a person who is equally selfless and self-knowing. This is a *moral beauty*.

What do you think "fair" means? Are we close to understanding it? Now that I recall a thought flitting around in the back of my head, Plato said something about beauty being truth and truth beauty, so I think our definition of "fair" is pretty close to his thinking.

Plato talks about the beauties of the earth. We talked a little about those when we used the example of Mountain Quest as a way to share beauty. These

beauties of the earth are to be used as "stepping stones" as we move from fair forms to fair practices to fair notes to fair living.

This ascent to beauty is Plato's ladder of love. The words are a bit strange to my ears of today, but we can dig a little deeper and try to understand them when we read a bit more of his work. It's pretty clear that "form" represents the human body. Almost everyone has loved someone they thought was beautiful. Then, as we continue on our path to the next stepping stone, we move from bodily beauty to the beauty of institutions, what today we more often than not think about as organizations. I wonder if Plato's word "practices" doesn't have to do with the work we do in these organizations?

The next stepping stone—what Plato refers to as notes—has to do with learning. We are here in this world experiencing (acting and interacting), and through this process *learning and expanding*. That certainly rings true! And that brings us back to reflecting on the beauty of thought and thought as beauty.

Finally, Plato says we reach absolute beauty. This is hard for me to understand. I have a scientist spouse who tells me there are no absolutes. "How can there be absolutes? To be absolute something would have always existed in the past and always will exist in the future. We as humans can't

experience that; thus, there are no absolutes in our existence."

That logic seems to turn around on itself. Certainly, he has a point, we do have finite lives. So, following his logic trail, absolutes couldn't exist in *our existence* since the human is finite. I mean, my dad always said you could depend on two things in life, taxes and dying. He also said there are two things you don't argue with your friend about: love and politics. Boy, that politics idea sure has proven itself right in our current political environment! My dad had a lot of wisdom.

Wait! What if Plato's "absolute beauty" isn't really referring to the physical focus, and maybe not the emotional focus or mental focus either! Just maybe, we're talking about the *beauty of the soul*. Absolute beauty is achieving beauty at the soul level! Now I can understand why this is called the ladder of love. Beauty and love work together.

* * * * *

EXERCISE: *Inner Art*

STEP 1: Close your eyes and create a picture of the beauty you have experienced in your mind's eye, or an echo of that beauty in your heart. This could be a place, perhaps the country or a historic building, your favorite piece of art, or a person you love.

STEP 2: Revel in the experience. Feel it. Use all of your senses and become fully immersed in the experience.

STEP 3: Slowly, let it fade away and open our eyes.

STEP 4: Now, in this quiet place of peace, REFLECT on these questions:

How do you feel when you are surrounded by beauty, something you personally think is beautiful?

How do you feel when you understand a concept that is simple and elegant and excites all of your senses?

How does this remembering make you feel?

* * * * *

Beauty, by definition, is your own special acknowledgment and appreciation of something that makes you feel good. As you can experience, when we bring beauty to mind all of our senses of form— and our two inner senses—are engaged fully and come into balance. There is no room left for anything else in our hearts and minds.

Similar to what was accomplished by our ancestors during the period of history we describe as the Renaissance—the time span between the 14th and 17th century—the creation and sharing of beauty is a way of circumventing the long and often arduous development of the mind. It, quite literally, provides

us a way to leap forward as individuals—and as a civilization—in consciousness!

The physicist Niles MacFlouer says that beauty can leapfrog over clogged senses, break through a log jam, and overcome force, allowing light to enter. It is a short-circuit to thinking, enabling us to circumvent the tedium of everyday life in an instant, and inject a feeling of appreciation, love and joy into the essence of our lives.

When we purposefully intend (choose) to perceive beauty through all of our senses, they are unified during that experience. And, unlike an intuitive flash which quickly comes and goes, we can *choose* to stay in the experience of beauty for a period of time.

<<<<<<<◇>>>>>>>

INSIGHT: **Beauty is a short-circuit to thinking, enabling us to circumvent the tedium of everyday life in an instant, and inject a feeling of appreciation, love and joy into our lives.**

<<<<<<<◇>>>>>>>

Once we experience beauty—and as we continue to have experiences of beauty—life is never the same. We expand. Our consciousness expands. Everything is different from that point forward. And when beauty is shared with others, they have the opportunity to share that same expansion.

Beauty is transcendent.

[Your Thoughts]

What does this mean to me?

All right, let's get down to the bottom line here. This stuff is pretty good, and yes, some of it makes good sense. But what is my take-away? How can all this make a difference in my experience of life, in my job, in my relationships?

In good business fashion, let's bullet a few highlights:

 Since all of your senses are fully engaged in the experience of beauty, there's no room for negative emotions to hang on. You want to get rid of negative feelings? Recall and reflect on something that is beautiful, or immerse yourself in an experience of beauty.

 Remember that everything you see around you was a thought first. Make sure YOUR thoughts reflect the level of beauty you want in your life!

 Whether an artist or an appreciator, choose to engage in art experiences that make you feel good and bring beauty into your life.

 Beauty is love made visible. Remember Plato's ladder of love. The love you feel for another, the beauty you see in that love, will lead you toward the beauty of your soul.

 Your body is YOUR creation, and just as much a product of what you think and feel as what you eat, drink and breath and how you exercise it.

 By creating a beautiful environment and sharing it, we are both expanding our *self* and advocating beauty in the senses of others.

Through beauty, you can circumvent the tedium of everyday life in an instant, and inject a feeling of appreciation, love and joy into your life!

Got it? Yes? *YOU are beautiful!*

This volume of **Conscious Look Books** builds conversationally on the ideas presented in *The Profundity and Bifurcation of Change Part V: Living the Future*, largely presented in Chapter 33: "The Harmony of Beauty." Co-authors of the original text include David Bennet, Arthur Shelley, Theresa Bullard, John Lewis and Donna Panucci. Full references are available in the original text, which is published by MQIPress, Frost, WV (2017), and available as an eBook on www.amazon.com

Endnotes

[1] Quoted from Epstein, M. (1995). *Thoughts without a Thinker*. New York: Basic Books, ix.

[2] Quoted from Besant, A. and Leadbeater, C.W. (1999). *Thought-forms*. Wheaton, IL: Quest Books, 8 and 67, respectively.

[3] Quoted from Statista (2016). Live theater visitors retrieved 10/8/2016 from www.statista.com/statistics/227494/live-theater-visitors-usa/

[4] The work of Reefka Schneider is featured in the books *Drawing Border Lives/Fronteras: Dibujando las vidas fronterizas* and *The Magic of Mariachi/La Magia del Mariachi*. They are available on amazon.com, Barnes and Noble and through their publisher, Wings Press.

[5] Quoted from Plato (2006). *Symposium* at 210d (Nehamas & Woodruff translation) in Haidt, J., *The Happiness Hypothesis: finding Modern Truth in Ancient Wisdom*. New York: Basic Books.

[6] Quoted from Mulford, P. (2007). *Thoughts are Things*. New York: Barnes & Noble, 60 and 73, respectively.

The Volumes in
Possibilities that are YOU!

Made in the USA
Columbia, SC
04 June 2021